A great grief has taught me more than any minister
and when feeling most alone
I find refuge in the Almighty Friend.

LOUISA MAY ALCOTT

When you're between a rock and a hard place
it won't be a dead end
Because I am GOD *your personal God.*

THE MESSAGE

LITERARY PORTALS TO PRAYER™

LOUISA MAY ALCOTT

ILLUMINATED BY

COMPILED AND INTRODUCED BY

SUSAN BAILEY

LOUISA MAY ALCOTT
Illuminated by *The Message*
Compiled and introduced by Susan Bailey

Series Editor, Gregory F. Augustine Pierce
Design and typesetting by Harvest Graphics
Cover image under license from Bigstock

Published by ACTA Publications, 4848 N. Clark St.,
Chicago, IL 60640, (800) 397-2282, actapublications.com

Library of Congress Number: 2015955667
ISBN: 978-0-87946-623-7 (standard edition)
ISBN: 978-0-87946-632-9 (enhanced-size edition)
Printed in the United States of America by Total Printing Systems
Year 25 24 23 22 21 20 19 18 17 16
Printing 12 11 10 9 8 7 6 5 4 3 2 First

♻ Text printed on 30% post-consumer recycled paper

CONTENTS

Prayer is sometimes difficult. Perhaps we need spiritual inspiration. Something to reignite our spiritual life. A way to initiate a new and fruitful spiritual direction.

Great literature can do these things: inspire, ignite, and initiate.

Which is why ACTA Publications is publishing a series of "Literary Portals to Prayer." The idea is simple: take insightful passages from great authors whose work has stood the test of time and illuminate each selection with a well-chosen quotation from the Bible on the same theme.

To do this, we use a relatively new translation by Eugene Peterson called *The Message: Catholic/Ecumenical Edition*. It is a fresh, compelling, challenging, and faith-filled translation of the Scriptures from ancient languages into contemporary American English that sounds as if it was written yesterday. *The Message* may be new to you, or you may already know it well, but see if it doesn't illuminate these writings of Louisa May Alcott in delightful ways.

We publish the books in this series in a size that can easily fit in pocket or purse and find a spot on kitchen table, bed stand, work bench, study desk, or exercise machine. We also publish each title in an enhanced-size for both public and private use. These books are meant to be used in a variety of ways. And we feature a variety of authors so you can find the one or ones that can kick-start your prayer life.

So enjoy these portals to prayer by Louisa May Alcott

illuminated by *The Message*. And look for others in this series, including Hans Christian Andersen, Jane Austen, Charles Dickens, Elizabeth Gaskell, Herman Melville, William Shakespeare, and others. Consider them, if you will, literary *lectio divina*.

<div align="right">

Gregory F. Augustine Pierce
President and Publisher
ACTA Publications
</div>

❧

REGARDING SPELLING, PUNCTUATION, AND CAPITALIZATION IN ALCOTT'S WORK

In very few instances, we have altered the spelling of a word, as for instance "cozily" for "cosily" in Beth's visit to Mr. Laurence. Also, we have changed older spellings of words to contemporary versions, for example, "today" for "to-day." Punctuation and capitalization we have left alone, unless it might confuse the modern reader. Where we start a quote in mid-sentence or add a word for clarity, we merely do so, rather than distract the reader with ellipses or brackets.

In her time, Louisa May Alcott was not considered religious; neither she nor any member of her family had any formal affiliation with a church. Critics complained that her classic, *Little Women*, had the March sisters performing a melodramatic play on the birthday of Christ.[1] *The Ladies Repository* warned that while *Little Women* is "Capital...our Sabbath Schools will all want it,"[2] it also added that "it is not a Christian book. It is religion without spirituality, and salvation without Christ. It is not a good book for the Sunday school library."[3]

The irony of that last review was not lost on me. Throughout her writing, which Alcott called "moral pap for the young,"[4] I continually discover meaningful spiritual nuggets. Oftentimes truths are revealed in the clever metaphors she used to tickle the imaginations of her young readers. Her stories never sought to shield children from real life; poverty, illness, death, and the struggle to master one's moral life were common themes. As a result, a special empathy coupled with respect existed between Alcott and her juvenile audience.[5] That relationship, passed down from mothers to daughters over the years, has kept several of Louisa May Alcott's works popular with today's readers.

Spirituality is not limited to her juvenile fiction. Pilgrimages are evidenced in some of Alcott's adult novels. Sylvia Yule (*Moods*) and Christie Devon (*Work: A Story of Experience*) struggle with faith, love, work, marriage, loss, and despair;

their life experiences lead them to discover who they are and how God figures into their lives.

Some of Alcott's most poignant writing revolves around the suffering and death of virtuous people. She processed the tragic demise of her younger sister Elizabeth at age twenty-three into a series of spiritual lessons on how to live and die with grace and dignity despite horrific and prolonged suffering. Adopting Lizzie as her spiritual guide,[6] Alcott shared her lessons most notably through the illness and death of Beth March in *Little Women* and John Suhre, the noble soldier in *Hospital Sketches*.

Critics of her day did not understand Alcott's *personal* brand of spirituality. In her view, churches presented a formal religion lacking in life, joy, or substance; God was to be feared rather than loved.[7] As a result of her unusual upbringing, Louisa May Alcott learned to see God not in the pulpit or the congregation but in nature and everyday life as an accessible and loving Father and Friend. It was that innate part of her being which poured forth from her pen. In *Little Women* Alcott writes, "Many wise and true sermons are preached us every day by unconscious ministers in street, school, office, or home...."[8]

Alcott grew up among some of the most innovative thinkers of the day. Her father, Amos Bronson Alcott (referred to as "Bronson"), was a founding member of the Transcendentalist movement that flourished in New England in the 1830s. Fellow Transcendentalists Ralph Waldo Emerson and Henry David Thoreau were close friends and neighbors for many years. Transcendentalism reacted to the then-present state of

religion, pushing back against cold rationalism and the Calvinist thinking of the intrinsic evil of mankind. People instead were considered to be good and could use their intuition to experience God through nature and within their own hearts and souls. [9]

The "church" to Bronson was the home; it was here where his children received their training in Christian living. An innovative educator, he believed that children were the closest to the Divine as they had not yet been corrupted by the world and that it was his job to bring forward what was already within their hearts and souls. [10] He read the scriptures aloud to his daughters and interpreted the meaning for them. A diary entry from his eldest daughter, Anna, at age eight describes her appreciation for her father's religious instruction: "I went to Mr. Barnard this morning. I wish he would preach about something that I could understand as father does when he talks with me about being good. After I came home, father read about God's making the World, about Adam and Eve in the Garden of Eden, eating the forbidden fruit and being sent out of the garden, and about Cain's slaying his brother Abel. Father explained it to me so that I might understand it. He wishes me to understand all I read. He talked with us about loving one another." [11]

The girls' mother, Abba, provided practical examples of charity by giving to the poor out of the family's need. Sacred music also played a role in their spiritual development, as demonstrated by family and friends gathering around the piano to sing hymns in many of Alcott's stories.

Bronson Alcott's greatest spiritual influence, however,

was not the Bible but *The Pilgrim's Progress* by John Bunyan. Originally published in 1678 and allegorical in nature, it is one of the most enduring stories of faith ever written. *The Pilgrim's Progress* revolves around protagonist Christian and his journey from the "City of Destruction" (his home) to the "Celestial City" (heaven). His pilgrimage towards perfection would at times be harrowing, filled with burdens (most especially the weight of his sins), sacrifices, and suffering. Through his own perseverance and the help of others, he is finally welcomed into the Celestial City.[12]

Bunyan's book was well-known to people of Alcott's time, and the sisters fully embraced the allegory. As girls, they "played pilgrims," carrying physical burdens on their backs while climbing up and down the attic stairs of their Concord, Massachusetts, home; this is referenced in chapter one of *Little Women*.[13] Alcott structured *Little Women* around *The Pilgrim's Progress*, as evidenced by the chapter titles: Playing Pilgrims, Burdens, Beth Find the Palace Beautiful, Jo Meets Apollyon, The Valley of the Shadow, and so forth. Bunyon's classic was used as the spiritual and moral core of the book, with each chapter providing lessons for the reader.[14] In keeping with her Transcendentalist upbringing, common moral dilemmas replaced high-minded religious thought.[15] This successful formula of allegory and morality, blended with real life characters and experiences, became the hallmark of Alcott's juvenile fiction.

Because of their parents' insistence on self-examination and introspection, the girls were required to keep journals of their moral progress and share what they had written with

family members. This became a lifelong habit for Alcott, giving us a rare look inside the author; we can actually trace her life experiences and struggles to characters and stories in her books.

Throughout my life I have been edified and comforted by Louisa May Alcott's brand of personal spirituality; it gives me great pleasure now to share these passages with you. Much has been written about Alcott as a writer, feminist, and reformer. I am hoping this little volume will highlight another equally important part of Alcott's life and writing that is dearly loved by children and adults from around the world. Spiritual truth is timeless, and a hunger for God has been placed deep within us. May these passages and their accompanying verses from *The Message* by Eugene Peterson stimulate your heart and mind, turning you ever closer toward your own Heavenly Parent, no matter how you imagine or describe that divine reality.

I am indebted to members of my blog community (*Louisa May Alcott is My Passion*) for suggestions of certain passages: Nancy Gluck, Gabrielle Donnelly, Erin Blakemore, Julie Dunlap, and Emily Demuth Ishida—thank you for your contributions, which have enriched this volume.

Susan Bailey
North Grafton, Massachusetts

1. Daniel Shealy, editor, *Little Women: An Annotated Edition* (Belknap Press, 2013), 18.
2. Harriet Reisen, *Louisa May Alcott: The Woman Behind Little Women* (Henry Holt and Co.; First Edition, 2009), 217.
3. Anne K. Phillips and Gregory Eiselein, editors, *Little Women by Louisa May Alcott*, A Norton Critical Edition (W.W. Norton & Company, 2004), 549.
4. Ednah Dow Cheney, *Louisa May Alcott: Her Life, Letters, and Journals* (Roberts Brothers, 1889), 296.
5. From a presentation by Cathlin Davis, PhD, at Orchard House, Concord, MA, July 15, 2014.
6. Cheney, 102.
7. Louisa May Alcott, *Work: A Story of Experience* (Penguin Books, 1994), 115-116
8. Louisa May Alcott, *Little Women* (Sterling, 2004), 322
9. http://louisamayalcott.org/bronsontext.html
10. Madelon Bedell, *The Alcotts: Biography of a Family* (Clarkson N. Potter, Inc., 1980), 39.
11. From the diary of Anna Alcott, Sunday, December 22, 1839, Concord Library Special Collections, Box 4, Roll 8, Amos B Alcott Family Letters 1837 TO 1852 Vol. 1 TO Vol. V 1852-1855 (microfilm of Amos B. Alcott Family Letters collection, MS Am 1130.9-1130.12, housed at Houghton Library at Harvard University, Cambridge, MA).
12. From Wikipedia, https://en.wikipedia.org/wiki/The_Pilgrim%27s_Progress
13. Shealy, 51-52.
14. Ibid.
15. Ibid., 4.

LOUISA MAY ALCOTT

SELECTIONS FROM

Hospital Sketches, 1863

Little Women, 1868

Little Men, 1871

Louisa May Alcott:
Her Life, Letters, and Journals, 1889
(Edited by Ednah Dow Cheney)

Lulu's Library, The Candy Country, 1885

Moods (Second Revision), 1882

Rose in Bloom, 1876

Shawl Straps
(Aunt Jo's Scrap-Bag, Volume 2), 1878

Transcendental Wild Oats, 1873

Work: A Story of Experience, 1873

FASHIONABLE WISDOM

"I think you have something better, a contented one," said Sylvia, as the woman regarded her with no sign of envy or regret.

"I ought to have; nine years on a body's back can teach a sight of things that are wuth knowin'. I've learnt patience pretty well I guess, and contentedness ain't fur away, for though it sometimes seems ruther long to look forward to, perhaps nine more years layin' here, I jest remember it might have been wuss, and if I don't do much now there's all eternity to come."

Something in the woman's manner struck Sylvia as she watched her softly beating some tune on the sheet with her quiet eyes turned toward the light. Many sermons had been less eloquent to the girl than the look, the tone, the cheerful resignation of that plain face. She stooped and kissed it, saying gently—

"I shall remember this."

MOODS (1882), CHAPTER 7, A GOLDEN WEDDING

FASHIONABLE WISDOM

We, of course, have plenty of wisdom to pass on to you once you get your feet on firm spiritual ground, but it's not popular wisdom, the fashionable wisdom of high-priced experts that will be out-of-date in a year or so. God's wisdom is something mysterious that goes deep into the interior of his purposes. You don't find it lying around on the surface. It's not the latest message, but more like the oldest—what God determined as the way to bring out his best in us, long before we ever arrived on the scene. The experts of our day haven't a clue about what this eternal plan is. If they had, they wouldn't have killed the Master of the God-designed life on a cross. That's why we have this Scripture text:

> *No one's ever seen or heard anything like this,*
> *Never so much as imagined anything quite like it —*
> *What God has arranged for those who love him.*

But you've seen and heard it because God by his Spirit has brought it all out into the open before you.

I CORINTHIANS 2:6-10

MAKE YOURSELVES AT HOME

She lingered for half an hour, feeling unusually devout in that tranquil spot, with no best clothes to disturb her thoughts, no over-fussy sister to vex her spirit, no neglected duties or broken resolutions to make church-going a penitential period of remorse.

MOODS (1882), CHAPTER 8, SERMONS

MAKE YOURSELVES AT HOME

On your feet now—applaud GOD!
 Bring a gift of laughter,
 sing yourselves into his presence.

Know this: GOD is God, and God, GOD.
 He made us; we didn't make him.
 We're his people, his well-tended sheep.

Enter with the password: "Thank you!"
 Make yourselves at home, talking praise.
 Thank him. Worship him.

PSALM 100:1-4

21

BORN FROM ABOVE

"Do you believe in sudden conversions?" she asked presently.

"Yes; for often what seems sudden is only the flowering of some secret growth, unsuspected till the heat of pain or passion calls it out. We feel the need of help that nothing human can give us, instinctively ask it of a higher power, and, receiving it in marvelous ways, gratefully and devoutly say, 'I believe.'"

MOODS (1882), CHAPTER 8, SERMONS

BORN FROM ABOVE

Jesus said, "You're not listening. Let me say it again. Unless a person submits to this original creation—the 'wind-hovering-over-the-water' creation, the invisible moving the visible, a baptism into a new life—it's not possible to enter God's kingdom. When you look at a baby, it's just that: a body you can look at and touch. But the person who takes shape within is formed by something you can't see and touch—the Spirit—and becomes a living spirit.

"So don't be so surprised when I tell you that you have to be 'born from above'—out of this world, so to speak. You know well enough how the wind blows this way and that. You hear it rustling through the trees, but you have no idea where it comes from or where it's headed next. That's the way it is with everyone 'born from above' by the wind of God, the Spirit of God."

JOHN 3:5-8

LOVE NEVER GIVES UP

He seemed to cling to life, as if it were rich in duties and delights, and he had learned the secret of content. The only time I saw his composure disturbed was when my surgeon brought another to examine John, who scrutinized their faces with an anxious look, asking of the elder: "Do you think I shall pull through, sir?" "I hope so, my man." And, as the two passed on, John's eye still followed them, with an intentness which would have won a clearer answer from them, had they seen it. A momentary shadow flitted over his face; then came the usual serenity, as if, in that brief eclipse, he had acknowledged the existence of some hard possibility, and, asking nothing yet hoping all things, left the issue in God's hands, with that submission which is true piety.

HOSPITAL SKETCHES, CHAPTER 4, A NIGHT

LOVE NEVER GIVES UP

Love never gives up....
Puts up with anything,
Trusts God always,
Always looks for the best,
Never looks back,
But keeps going to the end.

I CORINTHIANS 13:4, 7

STAY HERE AND KEEP VIGIL

A few minutes later, as I came in again, with fresh rollers, I saw John sitting erect, with no one to support him, while the surgeon dressed his back. I had never hitherto seen it done; for, having simpler wounds to attend to, and knowing the fidelity of the attendant, I had left John to him, thinking it might be more agreeable and safe; for both strength and experience were needed in his case. I had forgotten that the strong man might long for the gentle tendance of a woman's hands, the sympathetic magnetism of a woman's presence, as well as the feebler souls about him. The Doctor's words caused me to reproach myself with neglect, not of any real duty perhaps, but of those little cares and kindnesses that solace homesick spirits, and make the heavy hours pass easier. John looked lonely and forsaken just then, as he sat with bent head, hands folded on his knee, and no outward sign of suffering, till, looking nearer, I saw great tears roll down and drop upon the floor. It was a new sight there; for, though I had seen many suffer, some swore, some groaned, most endured silently, but none wept. Yet it did not seem weak, only very touching, and straightway my fear vanished, my heart opened wide and took him in, as, gathering the bent head in my arms, as freely as if he had been a little child, I said, "Let me help you bear it, John."

HOSPITAL SKETCHES, CHAPTER 4, A NIGHT

STAY HERE AND KEEP VIGIL

Then Jesus went with them to a garden called Gethsemane and told his disciples, "Stay here while I go over there and pray." Taking along Peter and the two sons of Zebedee, he plunged into an agonizing sorrow. Then he said, "This sorrow is crushing my life out. Stay here and keep vigil with me." ...

When he came back to his disciples, he found them sound asleep. He said to Peter, "Can't you stick it out with me a single hour? Stay alert; be in prayer so you don't wander into temptation without even knowing you're in danger. There is a part of you that is eager, ready for anything in God. But there's another part that's as lazy as an old dog sleeping by the fire."

MATTHEW 26:36-38, 40-41

HE DIDN'T SAY A WORD

As I went in, John stretched out both hands:

"I know you'd come! I guess I'm moving on, ma'am."

He was; and so rapidly that, even while he spoke, over his face I saw the grey veil falling that no human hand can lift. I sat down by him, wiped the drops from his forehead, stirred the air about him with the slow wave of a fan, and waited to help him die. He stood in sore need of help—and I could do so little; for, as the doctor had foretold, the strong body rebelled against death, and fought every inch of the way, forcing him to draw each breath with a spasm, and clench his hands with an imploring look, as if he asked, "How long must I endure this, and be still!" For hours he suffered dumbly, without a moment's respite, or a moment's murmuring; his limbs grew cold, his face damp, his lips white, and, again and again, he tore the covering off his breast, as if the lightest weight added to his agony; yet through it all, his eyes never lost their perfect serenity, and the man's soul seemed to sit therein, undaunted by the ills that vexed his flesh.

HOSPITAL SKETCHES, CHAPTER 4, A NIGHT

HE DIDN'T SAY A WORD

He took the punishment, and that made us whole.
 Through his bruises we get healed.
We're all like sheep who've wandered off and gotten lost.
 We've all done our own thing, gone our own way.
And GOD has piled all our sins, everything we've done wrong,
 on him, on him.

He was beaten, he was tortured,
 but he didn't say a word.
Like a lamb taken to be slaughtered
 and like a sheep being sheared,
 he took it all in silence.

ISAIAH 53:5-7

WHEN DID WE EVER SEE YOU?

It was the only cry pain or death had wrung from him, the only boon he had asked; and none of us could grant it.... The first red streak of dawn was warming the grey east, a herald of the coming sun; John saw it, and with the love of light which lingers in us to the end, seemed to read in it a sign of hope of help, for, over his whole face there broke that mysterious expression, brighter than any smile, which often comes to eyes that look their last. He laid himself gently down; and... lapsed into a merciful unconsciousness, which assured us that for him suffering was forever past. He died then; for, though the heavy breaths still tore their way up for a little longer, they were but the waves of an ebbing tide that beat unfelt against the wreck, which an immortal voyager had deserted with a smile. He never spoke again, but to the end held my hand close, so close that when he was asleep at last, I could not draw it away. Dan helped me, warning me as he did so that it was unsafe for dead and living flesh to lie so long together; but though my hand was strangely cold and stiff, and four white marks remained across its back, even when warmth and color had returned elsewhere, I could not but be glad that, through its touch, the presence of human sympathy, perhaps, had lightened that hard hour.

HOSPITAL SKETCHES, CHAPTER 4, A NIGHT

WHEN DID WE EVER SEE YOU?

"Then those 'sheep' are going to say, 'Master, what are you talking about? When did we ever see you hungry and feed you, thirsty and give you a drink? And when did we ever see you sick or in prison and come to you?' Then the King will say, 'I'm telling the solemn truth: Whenever you did one of these things to someone overlooked or ignored, that was me—you did it to me.'"

MATTHEW 25:37-40

A SAFE-HOUSE FOR THE BATTERED

There were six dolls to be taken up and dressed every morning, for Beth was a child still and loved her pets as well as ever; not one whole or handsome one among them; all were outcasts till Beth took them in; for when her sisters outgrew these idols, they passed to her, because Amy would have nothing old or ugly. Beth cherished them all the more tenderly for that very reason, and set up a hospital for infirm dolls. No pins were ever stuck into their cotton vitals; no harsh words or blows were ever given them; no neglect ever saddened the heart of the most repulsive, but all were fed and clothed, nursed and caressed with an affection which never failed. One forlorn fragment of *dollanity* had belonged to Jo; and, having led a tempestuous life, was left a wreck in the rag-bag, from which dreary poorhouse it was rescued by Beth, and taken to her refuge. Having no top to its head, she tied on a neat little cap, and as both arms and legs were gone, she hid these deficiencies by folding it in a blanket, and devoting her best bed to this chronic invalid…. She brought it bits of bouquets, she read to it, took it out to breathe fresh air, hidden under her coat; she sang it lullabys and never went to bed without kissing its dirty face and whispering tenderly, "I hope you'll have a good night, my poor dear."

LITTLE WOMEN, CHAPTER 4, BURDENS

A SAFE-HOUSE FOR THE BATTERED

GOD's a safe-house for the battered,
a sanctuary during bad times.
The moment you arrive, you relax;
you're never sorry you knocked.

PSALM 9:9-10

TRANSFERRED FROM DEATH TO LIFE

So Beth lay down on the sofa, the others returned to their work, and the Hummels were forgotten. An hour passed: Amy did not come; Meg went to her room to try on a new dress; Jo was absorbed in her story; and Hannah was sound asleep before the kitchen fire, when Beth quietly put on her hood, filled her basket with odds and ends for the poor children, and went out into the chilly air, with a heavy head and a grieved look in her patient eyes. It was late when she came back....

"Christopher Columbus! What's the matter?" cried Jo....

"Oh, Jo, the baby's dead!"

"What baby?"

"Mrs. Hummel's; it died in my lap before she got home," cried Beth, with a sob.

"My poor dear, how dreadful for you! I ought to have gone," said Jo, taking her sister in her lap as she sat down in her mother's big chair, with a remorseful face.

"It wasn't dreadful, Jo, only so sad! I saw in a minute that it was sicker, but Lottchen said her mother had gone for a doctor, so I took baby and let Lotty rest. It seemed asleep, but all of a sudden it gave a little cry and trembled, and then lay very still. I tried to warm its feet, and Lotty gave it some milk, but it didn't stir, and I knew it was dead."

"Don't cry, dear! What did you do?"

"...it was very sad, and I cried with them...."

LITTLE WOMEN, CHAPTER 17, LITTLE FAITHFUL

TRANSFERRED FROM DEATH TO LIFE

The way we know we've been transferred from death to life is that we love our brothers and sisters. Anyone who doesn't love is as good as dead....

This is how we've come to understand and experience love: Christ sacrificed his life for us. This is why we ought to live sacrificially for our fellow believers, and not just be out for ourselves. If you see some brother or sister in need and have the means to do something about it but turn a cold shoulder and do nothing, what happens to God's love? It disappears. And you made it disappear.

I JOHN 3:14, 16-17

LOVE BANISHES FEAR

They would have been still more amazed if they had seen what Beth did afterward. If you will believe me, she went and knocked at the study door, before she gave herself time to think; and when a gruff voice called out, "Come in!" she did go in, right up to Mr. Laurence, who looked quite taken aback, and held out her hand, saying, with only a small quaver in her voice, "I came to thank you, sir, for—." But she didn't finish, for he looked so friendly that she forgot her speech and, only remembering that he had lost the little girl he loved, she put both arms round his neck, and kissed him.

If the roof of the house had suddenly flown off, the old gentleman wouldn't have been more astonished; but he liked it; oh, dear, yes! he liked it amazingly! and was so touched and pleased by that confiding little kiss that all his crustiness vanished; and he just set her on his knee, and laid his wrinkled cheek against her rosy one, feeling as if he had got his own little granddaughter back again. Beth ceased to fear him from that moment, and sat there talking to him as cozily as if she had known him all her life; for love casts out fear, and gratitude can conquer pride.

LITTLE WOMEN, CHAPTER 6,
BETH FINDS THE PALACE BEAUTIFUL

LOVE BANISHES FEAR

God is love. When we take up permanent residence in a life of love, we live in God and God lives in us. This way, love has the run of the house, becomes at home and mature in us, so that we're free of worry on Judgment Day—our standing in the world is identical with Christ's. There is no room in love for fear. Well-formed love banishes fear. Since fear is crippling, a fearful life—fear of death, fear of judgment—is one not yet fully formed in love.

We, though, are going to love—love and be loved. First we were loved, now we love. He loved us first.

I JOHN 4:17-19

WORDS KILL

She had cherished her anger till it grew strong, and took possession of her, as evil thoughts and feelings always do unless cast out at once. As Laurie turned the bend, he shouted back—

"Keep near the shore. It isn't safe in the middle."

Jo heard, but Amy was just struggling to her feet, and did not catch a word. Jo glanced over her shoulder, and the little demon she was harboring said in her ear—

"No matter whether she heard or not, let her take care of herself."

Laurie had vanished round the bend; Jo was just at the turn, and Amy, far behind, striking out toward the smoother ice in the middle of the river. For a minute Jo stood still, with a strange feeling in her heart; then she resolved to go on, but something held and turned her round, just in time to see Amy throw up her hands and go down, with a sudden crash of rotten ice, the splash of water, and a cry that made Jo's heart stand still with fear. She tried to call Laurie, but her voice was gone; she tried to rush forward, but her feet seemed to have no strength in them; and, for a second, she could only stand motionless, staring with a terror-stricken face, at the little blue hood above the black water.

LITTLE WOMEN, CHAPTER 8, JO MEETS APOLLYON

WORDS KILL

"You're familiar with the command to the ancients, 'Do not murder.' I'm telling you that anyone who is so much as angry with a brother or sister is guilty of murder. Carelessly call a brother 'idiot!' and you just might find yourself hauled into court. Thoughtlessly yell 'stupid!' at a sister and you are on the brink of hellfire. The simple moral fact is that words kill."

MATTHEW 5:21-22

GOD WILL NEVER LET YOU DOWN

"Laurie did it all; I only let her go. Mother, if she *should* die, it would be my fault," and Jo dropped down beside the bed in a passion of penitent tears, telling all that had happened, bitterly condemning her hardness of heart, and sobbing out her gratitude for being spared the heavy punishment which might have come upon her.

"It's my dreadful temper! I try to cure it; I think I have, and then it breaks out worse than ever. Oh, mother! what shall I do! What shall I do?" cried poor Jo, in despair.

"Watch and pray, dear, never get tired of trying; and never think it is impossible to conquer your fault," said Mrs. March, drawing the blowzy head to her shoulder, and kissing the wet cheek so tenderly that Jo cried even harder.

"You don't know; you can't guess how bad it is! It seems as if I could do anything when I'm in a passion; I get so savage, I could hurt anyone and enjoy it. I'm afraid I *shall* do something dreadful some day, and spoil my life, and make everybody hate me. Oh, mother! help me, do help me!"

"I will, my child; I will. Don't cry so bitterly, but remember this day, and resolve, with all your soul, that you will never know another like it. Jo, dear, we all have our temptations, some far greater than yours, and it often takes us all our lives to conquer them."

LITTLE WOMEN, CHAPTER 8, JO MEETS APOLLYON

GOD WILL NEVER LET YOU DOWN

No test or temptation that comes your way is beyond the course of what others have had to face. All you need to remember is that God will never let you down; he'll never let you be pushed past your limit; he'll always be there to help you come through it.

I CORINTHIANS 10:13

A GENTLE LISTENER

"How did you learn to keep still? That is what troubles me—for the sharp words fly out before I know what I'm about; and the more I say the worse I get, till it's a pleasure to hurt people's feelings, and say dreadful things. Tell me how you do it, Marmee dear."

"My good mother used to help me—"

"As you do us—" interrupted Jo, with a grateful kiss.

"But I lost her when I was a little older than you are, and for years had to struggle on alone, for I was too proud to confess my weakness to anyone else. I had a hard time, Jo, and shed a good many bitter tears over my failures; for, in spite of my efforts, I never seemed to get on. Then your father came, and I was so happy that I found it easy to be good. But by-and-by, when I had four little daughters round me, and we were poor, then the old trouble began again; for I am not patient by nature, and it tried me very much to see my children wanting anything."

"Poor mother! What helped you then?"

"Your father, Jo. He never loses patience—never doubts or complains—but always hopes, and works and waits so cheerfully, that one is ashamed to do otherwise before him. He helped and comforted me, and showed me that I must try to practise all the virtues I would have my little girls possess, for I was their example. It was easier to try for your sakes than for my own...."

LITTLE WOMEN, CHAPTER 8, JO MEETS APOLLYON

A GENTLE LISTENER

Run away from infantile indulgence. Run after mature righteousness—faith, love, peace—joining those who are in honest and serious prayer before God.... God's servant must not be argumentative, but a gentle listener and a teacher who keeps cool, working firmly but patiently with those who refuse to obey.

2 TIMOTHY 2:22, 24

YOU NEVER, NEVER QUIT

"My child, the troubles and temptations of your life are beginning and may be many; but you can overcome and outlive them all, if you learn to feel the strength and tenderness of your Heavenly Father as you do that of your earthly one. The more you love and trust Him, the nearer you will feel to Him, and the less you will depend on human power and wisdom. His love and care never tire or change, can never be taken from you, but may become the source of lifelong peace, happiness, and strength. Believe this heartily, and go to God with all your little cares, and hopes, and sins, and sorrows, as freely and confidingly as you come to your mother."

Jo's only answer was to hold her mother close, and in the silence which followed the sincerest prayer she had ever prayed left her heart, without words; for in that sad, yet happy hour, she had learned not only the bitterness of remorse and despair, but the sweetness of self-denial and self-control; and led by her mother's hand, she had drawn nearer to the Friend who always welcomes every child with a love stronger than that of any father, tenderer than that of any mother.

LITTLE WOMEN, CHAPTER 8, JO MEETS APOLLYON

YOU NEVER, NEVER QUIT

But you, O God, are both tender and kind,
not easily angered, immense in love,
and you never, never quit.
So look me in the eye and show kindness,
give your servant the strength to go on,
save your dear, dear child!

PSALM 86:15-16

WHEN WE LIVE IN GOD'S WAY

Amy came out so strong on this occasion, that I think the good thoughts in the little chapel really began to bear fruit. She dried her tears quickly, restrained her impatience to see her mother, and never even thought of the turquoise ring, when the old lady heartily agreed in Laurie's opinion, that she behaved "like a capital little woman."… She would very gladly have gone out to enjoy the bright wintry weather; but discovering that Laurie was dropping with sleep in spite of manful efforts to conceal the fact, she persuaded him to rest on the sofa, while she wrote a note to her mother. She was a long time about it….

Amy was the happiest of all, when she sat in her mother's lap and told her trials, receiving consolation and compensation in the shape of approving smiles and fond caresses. They were alone together in the chapel, to which her mother did not object when its purpose was explained to her.

"On the contrary, I like it very much, dear," looking from the dusty rosary to the well-worn little book, and the lovely picture with its garland of evergreen. "It is an excellent plan to have some place where we can go to be quiet, when things vex or grieve us. There are a good many hard times in this life of ours, but we can always bear them if we ask help in the right way. I think my little girl is learning this."

LITTLE WOMEN, CHAPTER 20, CONFIDENTIAL

WHEN WE LIVE IN GOD'S WAY

But what happens when we live God's way? He brings gifts into our lives, much the same way that fruit appears in an orchard—things like affection for others, exuberance about life, serenity. We develop a willingness to stick with things, a sense of compassion in the heart, and a conviction that a basic holiness permeates things and people. We find ourselves involved in loyal commitments, not needing to force our way in life, able to marshal and direct our energies wisely.

GALATIANS 5:22-23

BRIGHTER AND MORE BEAUTIFUL

"I observed that Amy took drumsticks at dinner, ran errands for her mother all the afternoon, gave Meg her place tonight, and has waited on every one with patience and good humor. I also observe that she does not fret much, nor prink at the glass, and has not even mentioned a very pretty ring which she wears; so I conclude that she has learned to think of other people more, and of herself less, and has decided to try and mould her character as carefully as she moulds her little clay figures. I am glad of this; for though I should be very proud of a graceful statue made by her, I shall be infinitely prouder of a lovable daughter, with a talent for making life beautiful to herself and others."

LITTLE WOMEN, CHAPTER 22, PLEASANT MEADOWS

BRIGHTER AND MORE BEAUTIFUL

Whenever, though, they turn to face God as Moses did, God removes the veil and there they are—face-to-face! They suddenly recognize that God is a living, personal presence, not a piece of chiseled stone. And when God is personally present, a living Spirit, that old, constricting legislation is recognized as obsolete. We're free of it! All of us! Nothing between us and God, our faces shining with the brightness of his face. And so we are transfigured much like the Messiah, our lives gradually becoming brighter and more beautiful as God enters our lives and we become like him.

2 CORINTHIANS 3:16-18

THE RECIPE FOR BEING HAPPY

"I read in *Pilgrim's Progress* today how, after many troubles, Christian and Hopeful came to a pleasant green meadow, where lilies bloomed all year round, and there they rested happily, as we do now, before they went on to their journey's end," answered Beth.... "It's singing time now, and I want to be in my old place. I'll try to sing the song of the shepherd boy which the Pilgrims heard. I made the music for father, because he likes the verses."...

Beth softly touched the keys, and, in the sweet voice they had never thought to hear again, sung to her own accompaniment the quaint hymn, which was a singularly fitting song for her:—

"He that is down need fear no fall;
 He that is low no pride;
He that is humble ever shall
 Have God to be his guide.

"I am content with what I have,
 Little be it or much,
And, Lord! contentment still I crave,
 Because Thou savest such."

LITTLE WOMEN, CHAPTER 22, PLEASANT MEADOWS

THE RECIPE FOR BEING HAPPY

I'm glad in God, far happier than you would ever guess—happy that you're again showing such strong concern for me. Not that you ever quit praying and thinking about me. You just had no chance to show it. Actually, I don't have a sense of needing anything personally. I've learned by now to be quite content whatever my circumstances. I'm just as happy with little as with much, with much as with little. I've found the recipe for being happy whether full or hungry, hands full or hands empty. Whatever I have, wherever I am, I can make it through anything in the One who makes me who I am. I don't mean that your help didn't mean a lot to me—it did. It was a beautiful thing that you came alongside me in my troubles.

PHILIPPIANS 4:10-14

PRACTICE THE SERVANT LIFE

Mrs. Chester, who, of course, resented the supposed ridicule of her daughter, said in a bland tone, but with a cold look—

"I find, dear, that there is some feeling among the young ladies about my giving *this* table to anyone but my girls. As this *is* the most prominent, and some say the most attractive table of all, and they are the chief getters-up of the fair, it is thought best for them to take this place. I'm sorry, but I know you are too sincerely interested in the cause to mind a little personal disappointment, and you shall have another table if you like."...

"It shall be as you please, Mrs. Chester; I'll give up my place here at once, and attend to the flowers, if you like."

There was great indignation at home when she told her story that evening. Her mother said it was a shame, but told her she had done right....

"Because they are mean is no reason why I should be. I hate such things; and though I think I've a right to be hurt, I don't intend to show it. They will feel that more than angry speeches or huffy actions, won't they, Marmee?"

"That's the right spirit, my dear; a kiss for a blow is always best, though it's not very easy to give it sometimes," said her mother, with the air of one who had learned the difference between preaching and practicing.

LITTLE WOMEN, CHAPTER 30, CONSEQUENCES

PRACTICE THE SERVANT LIFE

"Here's another old saying that deserves a second look: 'Eye for eye, tooth for tooth.' Is that going to get us anywhere? Here's what I propose: 'Don't hit back at all.' If someone strikes you, stand there and take it. If someone drags you into court and sues for the shirt off your back, giftwrap your best coat and make a present of it. And if someone takes unfair advantage of you, use the occasion to practice the servant life. No more tit-for-tat stuff. Live generously."

MATTHEW 5:38-42

TRAINING US TO LIVE IN GOD'S WAY

In spite of various very natural temptations to resent and retaliate, Amy adhered to her resolution all the next day, bent on conquering her enemy by kindness. She began well, thanks to a silent reminder that came to her unexpectedly, but most opportunely. As she arranged her table that morning while the little girls were in the ante-room filling the baskets, she took up her pet production, a little book, the antique cover of which her father had found among his treasures, and in which, on leaves of vellum she had beautifully illuminated different texts. As she turned the pages, rich in dainty devices, with very pardonable pride, her eye fell upon one verse that made her stop and think. Framed in a brilliant scroll-work of scarlet, blue and gold, with little spirits of good-will helping one another up and down among the thorns and flowers, were the words, "Thou shalt love thy neighbor as thyself."

LITTLE WOMEN, CHAPTER 30, CONSEQUENCES

TRAINING US TO LIVE IN GOD'S WAY

But don't let it faze you. Stick with what you learned and believed, sure of the integrity of your teachers—why, you took in the sacred Scriptures with your mother's milk! There's nothing like the written Word of God for showing you the way to salvation through faith in Christ Jesus. Every part of Scripture is God-breathed and useful one way or another— showing us truth, exposing our rebellion, correcting our mistakes, training us to live God's way. Through the Word we are put together and shaped up for the tasks God has for us.

2 TIMOTHY 3:14-17

GIVE AWAY YOUR LIFE

Many wise and true sermons are preached us every day by unconscious ministers in street, school, office, or home; even a fair-table may become a pulpit, if it can offer the good and helpful words which are never out of season. Amy's conscience preached her a little sermon from that text, then and there; and she did what many of us don't always do, took the sermon to heart, and straightway put it in practice....

She heard May say, sorrowfully—

"It's too bad, for there *is* no time to make other things, and I don't want to fill up with odds and ends. The table was just complete then; now it's spoilt."

"I dare say she'd put them back if you asked her," suggested some one.

"How could I after all the fuss?" began May, but she did not finish, for Amy's voice came across the hall, saying pleasantly—

"You may have them, and welcome, without asking, if you want them. I was just thinking I'd offer to put them back, for they belong to your table rather than mine. Here they are, please take them, and forgive me if I was hasty in carrying them away last night."

As she spoke, Amy returned her contribution with a nod and a smile, and hurried away again, feeling that it was easier to do a friendly thing than it was to stay and be thanked for it.

LITTLE WOMEN, CHAPTER 30, CONSEQUENCES

GIVE AWAY YOUR LIFE

"Don't pick on people, jump on their failures, criticize their faults—unless, of course, you want the same treatment. Don't condemn those who are down; that hardness can boomerang. Be easy on people; you'll find life a lot easier. Give away your life; you'll find life given back, but not merely given back— given back with bonus and blessing. Giving, not getting, is the way. Generosity begets generosity."

LUKE 6:37-38

WITHOUT EXPECTING A RETURN

"Now I call that lovely of her, don't you?" cried one girl.

May's answer was inaudible, but another young lady, whose temper was evidently a little soured by making lemonade, added, with a disagreeable laugh, "Very lovely; for she knew she wouldn't sell them at her own table."

Now, that was hard; when we make little sacrifices we like to have them appreciated, at least, and for a minute Amy was sorry she had done it, feeling that virtue was not always its own reward. But it is, as she presently discovered; for her spirits began to rise, and her table to blossom under her skillful hands; the girls were very kind, and that one little act seemed to have cleared the atmosphere amazingly.

LITTLE WOMEN, CHAPTER 30, CONSEQUENCES

WITHOUT EXPECTING A RETURN

"I tell you, love your enemies. Help and give without expecting a return. You'll never—I promise—regret it. Live out this God-created identity the way our Father lives toward us, generously and graciously, even when we're at our worst. Our Father is kind; you be kind."

LUKE 6:35-36

YOUR TRUE FACE

Jo rashly took a plunge into the frothy sea of sensational literature....

Like most young scribblers, she went abroad for her characters and scenery, and banditti, counts, gypsies, nuns, and duchesses appeared upon her stage, and played their parts with as much accuracy and spirit as could be expected. Her readers were not particular about such trifles as grammar, punctuation, and probability, and Mr. Dashwood graciously permitted her to fill his columns at the lowest prices....

She soon became interested in her work—for her emaciated purse grew stout, and the little hoard she was making to take Beth to the mountains next summer grew slowly but surely, as the weeks passed. One thing disturbed her satisfaction, and that was that she did not tell them at home. She had a feeling that father and mother would not approve—and preferred to have her own way first, and beg pardon afterward. It was easy to keep her secret, for no name appeared with her stories....

She thought it would do her no harm, for she sincerely meant to write nothing of which she would be ashamed, and quieted all pricks of conscience by anticipations of the happy minute when she should show her earnings and laugh over her well-kept secret.

LITTLE WOMEN, CHAPTER 34, FRIEND

YOUR TRUE FACE

"You can't keep your true self hidden forever; before long you'll be exposed. You can't hide behind a religious mask forever; sooner or later the mask will slip and your true face will be known. You can't whisper one thing in private and preach the opposite in public; the day's coming when those whispers will be repeated all over town."

LUKE 12:2-3

DON'T EVER QUIT

Now Mr. Bhaer was a diffident man and slow to offer his own opinions....

He bore it as long as he could; but when he was appealed to for an opinion, he blazed up with honest indignation, and defended religion with all the eloquence of truth—an eloquence which made his broken English musical, and his plain face beautiful. He had a hard fight, for the wise men argued well; but he didn't know when he was beaten, and stood to his colors like a man. Somehow, as he talked, the world got right again to Jo; the old beliefs, that had lasted so long, seemed better than the new. God was not a blind force, and immortality was not a pretty fable, but a blessed fact. She felt as if she had solid ground under her feet again; and when Mr. Bhaer paused, out-talked but not one whit convinced, Jo wanted to clap her hands and thank him.

She did neither, but she remembered the scene, and gave the Professor her heartiest respect, for she knew it cost him an effort to speak out then and there, because his conscience would not let him be silent. She began to see that character is a better possession than money, rank, intellect, or beauty, and to feel that if greatness is what a wise man has defined it to be—"truth, reverence, and good-will"—then her friend Friedrich Bhaer was not only good, but great.

LITTLE WOMEN, CHAPTER 34, FRIEND

DON'T EVER QUIT

I can't impress this on you too strongly. God is looking over your shoulder. Christ himself is the Judge, with the final say on everyone, living and dead. He is about to break into the open with his rule, so proclaim the Message with intensity; keep on your watch. Challenge, warn, and urge your people. Don't ever quit. Just keep it simple.

You're going to find that there will be times when people will have no stomach for solid teaching, but will fill up on spiritual junk food—catchy opinions that tickle their fancy. They'll turn their backs on truth and chase mirages. But you—keep your eye on what you're doing; accept the hard times along with the good; keep the Message alive; do a thorough job as God's servant.

2 TIMOTHY 4:1-5

START RUNNING—AND NEVER QUIT

But when nothing remained of all her three months' work, except a heap of ashes, and the money in her lap, Jo looked sober, as she sat on the floor, wondering what she ought to do about her wages.

"I think I haven't done much harm *yet*, and may keep this to pay for my time," she said, after a long meditation, adding impatiently, "I almost wish I hadn't any conscience, it's so inconvenient. If I didn't care about doing right, and didn't feel uncomfortable when doing wrong, I should get on capitally. I can't help wishing, sometimes, that mother and father hadn't been so dreadfully particular about such things."

LITTLE WOMEN, CHAPTER 34, FRIEND

START RUNNING—AND NEVER QUIT

Do you see what this means—all these pioneers who blazed the way, all these veterans cheering us on? It means we'd better get on with it. Strip down, start running—and never quit! No extra spiritual fat, no parasitic sins. Keep your eyes on Jesus, who both began and finished this race we're in. Study how he did it. Because he never lost sight of where he was headed—that exhilarating finish in and with God—he could put up with anything along the way: Cross, shame, whatever. And now he's there, in the place of honor, right alongside God. When you find yourselves flagging in your faith, go over that story again, item by item, that long litany of hostility he plowed through. That will shoot adrenaline into your souls!

HEBREWS 12:1-3

LIKE SILVER

It was well for all that this peaceful time was given them as preparation for the sad hours to come; for by-and-by, Beth said the needle was "so heavy," and put it down forever; talking wearied her, faces troubled her, pain claimed her for its own, and her tranquil spirit was sorrowfully perturbed by the ills that vexed her feeble flesh. Ah me! Such heavy days, such long, long nights, such aching hearts and imploring prayers, when those who loved her best were forced to see the thin hands stretched out to them beseechingly, to hear the bitter cry, "Help me, help me!" and to feel that there was no help. A sad eclipse of the serene soul, a sharp struggle of the young life with death; but both were mercifully brief, and then the natural rebellion over, the old peace returned more beautiful than ever. With the wreck of her frail body, Beth's soul grew strong; and though she said little, those about her felt that she was ready, saw that the first pilgrim called was likewise the fittest, and waited with her on the shore, trying to see the Shining ones coming to receive her when she crossed the river.

LITTLE WOMEN, CHAPTER 40,
THE VALLEY OF THE SHADOW

LIKE SILVER

Bless our God, O peoples!
 Give him a thunderous welcome!
Didn't he set us on the road to life?
 Didn't he keep us out of the ditch?
He trained us first,
 passed us like silver through refining fires,
Brought us into hardscrabble country,
 pushed us to our very limit,
Road-tested us inside and out,
 took us to hell and back;
Finally he brought us
 to this well-watered place.

PSALM 66:8-12

WEAR LOVE

Often when she woke, Jo found Beth reading in her well-worn little book, heard her singing softly, to beguile the sleepless night, or saw her lean her face upon her hands, while slow tears dropped through the transparent fingers; and Jo would lie watching her, with thoughts too deep for tears, feeling that Beth, in her simple, unselfish way, was trying to wean herself from the dear old life, and fit herself for the life to come, by sacred words of comfort, quiet prayers, and the music she loved so well.

Seeing this did more for Jo than the wisest sermons, the saintliest hymns, the most fervent prayers that any voice could utter; for, with eyes made clear by many tears, and a heart softened by the tenderest sorrow, she recognized the beauty of her sister's life—uneventful, unambitious, yet full of the genuine virtues which "smell sweet, and blossom in the dust"; the self-forgetfulness that makes the humblest on earth remembered soonest in heaven, the true success which is possible to all.

LITTLE WOMEN, CHAPTER 40,
THE VALLEY OF THE SHADOW

WEAR LOVE

So, chosen by God for this new life of love, dress in the wardrobe God picked out for you: compassion, kindness, humility, quiet strength, discipline. Be even-tempered, content with second place, quick to forgive an offense. Forgive as quickly and completely as the Master forgave you. And regardless of what else you put on, wear love. It's your basic, all-purpose garment. Never be without it.

COLOSSIANS 3:12-14

WHEN YOU FEEL YOU'VE LOST

But someone did come and help her, though Jo did not recognize her good angels at once, because they wore familiar shapes, and used the simple spells best fitted to poor humanity. Often she started up at night, thinking Beth called her; and when the sight of the little empty bed made her cry with the bitter cry of unsubmissive sorrow, "Oh, Beth! come back! come back!" she did not stretch out her yearning arms in vain; for, as quick to hear her sobbing as she had been to hear her sister's faintest whisper, her mother came to comfort her. Not with words only, but the patient tenderness that soothes by a touch, tears that were mute reminders of a greater grief than Jo's, and broken whispers, more eloquent than prayers, because hopeful resignation went hand-in-hand with natural sorrow. Sacred moments! when heart talked to heart in the silence of the night, turning affliction to a blessing, which chastened grief and strengthened love. Feeling this, Jo's burden seemed easier to bear, duty grew sweeter, and life looked more endurable, seen from the safe shelter of her mother's arms.

LITTLE WOMEN, CHAPTER 42, ALL ALONE

WHEN YOU FEEL YOU'VE LOST

"You're blessed when you feel you've lost what is most dear to you. Only then can you be embraced by the One most dear to you."

MATTHEW 5:4

HEALTHY IN GOD, ROBUST IN LOVE

"It's just what you need to bring out the tender womanly half of your nature, Jo. You are like a chestnut burr, prickly outside, but silky-soft within, and a sweet kernal, if one can only get at it. Love will make you show your heart some day, and then the rough burr will fall off."

"Frost opens chestnut burrs, ma'am, and it takes a good shake to bring them down. Boys go nutting, and I don't care to be bagged by them," returned Jo, pasting away at the kite, which no wind that blows would ever carry up, for Daisy had tied herself on as a bob.

Meg laughed, for she was glad to see a glimmer of Jo's old spirit, but she felt it her duty to enforce her opinion by every argument in her power; and the sisterly chats were not wasted, especially as two of Meg's most effective arguments were the babies, whom Jo loved tenderly. Grief is the best opener for some hearts, and Jo's was nearly ready for the bag; a little more sunshine to ripen the nut, then, not a boy's impatient shake, but a man's hand reached up to pick it gently from the burr, and find the kernal sound and sweet. If she suspected this, she would have shut up tight, and been more prickly than ever; fortunately she wasn't thinking about herself, so when the time came, down she dropped.

LITTLE WOMEN, CHAPTER 42, ALL ALONE

HEALTHY IN GOD, ROBUST IN LOVE

No prolonged infancies among us, please. We'll not tolerate babes in the woods, small children who are an easy mark for impostors. God wants us to grow up, to know the whole truth and tell it in love—like Christ in everything. We take our lead from Christ, who is the source of everything we do. He keeps us in step with each other. His very breath and blood flow through us, nourishing us so that we will grow up healthy in God, robust in love.

EPHESIANS 4:14-16

THE SIMPLICITY OF A CHILD

The light of the shaded lamp that burned in the nursery shone softly on a picture hanging at the foot of Nat's bed. There were several others on the walls, but the boy thought there must be something peculiar about this one, for it had a graceful frame of moss and cones about it, and on a little bracket underneath stood a vase of wild flowers freshly gathered from the spring woods. It was the most beautiful picture of them all, and Nat lay looking at it, dimly feeling what it meant, and wishing he knew all about it.

"That's my picture," said a little voice in the room. Nat popped up his head, and there was Demi in his night-gown pausing on his way back from Aunt Jo's chamber, whither he had gone to get a cot for a cut finger.

"What is he doing to the children?" asked Nat.

"That is Christ, the Good Man, and He is blessing the children. Don't you know about Him?" said Demi, wondering.

"Not much, but I'd like to, He looks so kind," answered Nat, whose chief knowledge of the Good Man consisted in hearing His name taken in vain.

"I know all about it, and I like it very much, because it is true," said Demi.

LITTLE MEN, CHAPTER 3, SUNDAY

THE SIMPLICITY OF A CHILD

The people brought children to Jesus, hoping he might touch them. The disciples shooed them off. But Jesus was irate and let them know it: "Don't push these children away. Don't ever get between them and me. These children are at the very center of life in the kingdom. Mark this: Unless you accept God's kingdom in the simplicity of a child, you'll never get in." Then, gathering the children up in his arms, he laid his hands of blessing on them.

MARK 10:13-16

A TASTE OF GOD

"I found a very pretty book one day and wanted to play with it, but Grandpa said I mustn't, and showed me the pictures, and told me about them, and I liked the stories very much, all about Joseph and his bad brothers, and the frogs that came up out of the sea, and dear little Moses in the water, and ever so many more lovely ones, but I liked about the Good Man best of all, and Grandpa told it to me so many times that I learned it by heart, and he gave me this picture so I shouldn't forget, and it was put up here once when I was sick, and I left it for other sick boys to see."

"What makes Him bless the children?" asked Nat, who found something very attractive in the chief figure of the group.

"Because He loved them."

LITTLE MEN, CHAPTER 3, SUNDAY

A TASTE OF GOD

You've had a taste of God. Now, like infants at
the breast, drink deep of God's pure kindness.
Then you'll grow up mature and whole in God.

I PETER 2:2-3

GIVING YOURSELVES TO THE DOWN-AND-OUT

"Were they poor children?" asked Nat, wistfully.

"Yes, I think so; you see some haven't got hardly any clothes on, and the mothers don't look like rich ladies. He liked poor people, and was very good to them. He made them well, and helped them, and told rich people they must not be cross to them, and they loved Him dearly, dearly," cried Demi, with enthusiasm.

"Was He rich?"

"Oh no! He was born in a barn, and was so poor He hadn't any house to live in when He grew up, and nothing to eat sometimes, but what people gave Him, and He went round preaching to everybody, and trying to make them good, till the bad men killed Him."

"What for?" and Nat sat up in his bed to look and listen, so interested was he in this man who cared for the poor so much.

"I'll tell you all about it; Aunt Jo won't mind;" and Demi settled himself on the opposite bed, glad to tell his favorite story to so good a listener.

LITTLE MEN, CHAPTER 3, SUNDAY

GIVING YOURSELVES TO THE DOWN-AND-OUT

If you are generous with the hungry
 and start giving yourselves to the down-and-out,
Your lives will begin to glow in the darkness,
 your shadowed lives will be bathed in sunlight.
I will always show you where to go.
 I'll give you a full life in the emptiest of places—
 firm muscles, strong bones.
You'll be like a well-watered garden,
 a gurgling spring that never runs dry.
You'll use the old rubble of past lives to build anew,
 rebuild the foundations from out of your past.
You'll be known as those who can fix anything,
 restore old ruins, rebuild and renovate,
 make the community livable again.

ISAIAH 58:10-12

GET THE WORD OUT

But when she stole to the nursery door, and saw Nat eagerly drinking in the words of his little friends, while Demi told the sweet and solemn story as it had been taught him, speaking softly as he sat with his beautiful eyes fixed on the tender face above them, her own filled with tears, and she went silently away, thinking to herself—

"Demi is unconsciously helping the poor boy better than I can; I will not spoil it by a single word."

The murmur of the childish voice went on for a long time, as one innocent heart preached that great sermon to another, and no one hushed it. When it ceased at last, and Mrs. Bhaer went to take away the lamp, Demi was gone and Nat fast asleep, lying with his face toward the picture, as if he had already learned to love the Good Man who loved little children, and was a faithful friend to the poor. The boy's face was very placid, and as she looked at it she felt that if a single day of care and kindness had done so much, a year of patient cultivation would surely bring a grateful harvest from this neglected garden, which was already sown with the best of all seed by the little missionary in the night-gown.

LITTLE MEN, CHAPTER 3, SUNDAY

GET THE WORD OUT

You've been raised on the Message of the faith and have followed sound teaching. Now pass on this counsel to the followers of Jesus there, and you'll be a good servant of Jesus....

Get the word out. Teach all these things. And don't let anyone put you down because you're young. Teach believers with your life: by word, by demeanor, by love, by faith, by integrity.

I TIMOTHY 4:6, 11-13

FORGET ABOUT YOURSELF

"Some of my saints here were people of one idea, and though they were not very successful from a worldly point of view while alive, they were loved and canonized when dead," said Rose, who had been turning over a pile of photographs on the table and just then found her favorite, St. Francis, among them....

Rose...understood why her cousin preferred the soldierly figure with the sword to the ascetic with his crucifix. One was riding bravely through the world in purple and fine linen, with horse and hound and squires at his back; and the other was in a lazar-house, praying over the dead and dying. The contrast was a strong one, and the girl's eyes lingered longest on the knight, though she said thoughtfully, "Yours is certainly the pleasantest.... St. Francis gave himself to charity just when life was most tempting and spent years working for God without reward.... I won't give him up...."

ROSE IN BLOOM, CHAPTER 2,
OLD FRIENDS WITH NEW FACES

FORGET ABOUT YOURSELF

"If you don't go all the way with me, through thick and thin, you don't deserve me. If your first concern is to look after yourself, you'll never find yourself. But if you forget about yourself and look to me, you'll find both yourself and me."

MATTHEW 10:38-39

HE DOESN'T PLAY HIDE-AND-SEEK

Nowhere did Christie find this all-sustaining power, this paternal friend, and comforter, and after months of patient searching she gave up her quest, saying, despondently:

"I'm afraid I never shall get religion, for all that's offered me seems so poor, so narrow, or so hard that I cannot take it for my stay. A God of wrath I cannot love; a God that must be propitiated, adorned, and adored like an idol I cannot respect; and a God who can be blinded to men's iniquities through the week by a little beating of the breast and bowing down on the seventh day, I cannot serve. I want a Father to whom I can go with all my sins and sorrows, all my hopes and joys, as freely and fearlessly as I used to go to my human father, sure of help and sympathy and love. Shall I ever find Him?"

Alas, poor Christie! she was going through the sorrowful perplexity that comes to so many before they learn that religion cannot be given or bought, but must grow as trees grow, needing frost and snow, rain and wind to strengthen it before it is deep-rooted in the soul; that God is in the hearts of all, and they that seek shall surely find Him when they need Him most.

WORK: A STORY OF EXPERIENCE, CHAPTER 7, THROUGH THE MIST

HE DOESN'T PLAY HIDE-AND-SEEK

"The God who made the world and everything in it, this Master of sky and land, doesn't live in custom-made shrines or need the human race to run errands for him, as if he couldn't take care of himself. He makes the creatures; the creatures don't make him. Starting from scratch, he made the entire human race and made the earth hospitable, with plenty of time and space for living so we could seek after God, and not just grope around in the dark but actually find him. He doesn't play hide-and-seek with us. He's not remote; he's near. We live and move in him, can't get away from him! One of your poets said it well: 'We're the God-created.' Well, if we are the God-created, it doesn't make a lot of sense to think we could hire a sculptor to chisel a god out of stone for us, does it?"

ACTS 17:24-29

FORGIVEN, GRATEFUL

"Hush, my poor dear, and let me talk. You are not able to do anything, but rest, and listen. I knew how many poor souls went wrong when the devil tempted them; and I gave all my strength to saving those who were going the way I went. I had no fear, no shame to overcome, for I was one of them. They would listen to me, for I knew what I spoke; they could believe in salvation, for I was saved; they did not feel so outcast and forlorn when I told them you had taken me into your innocent arms, and loved me like a sister. With every one I helped my power increased, and I felt as if I had washed away a little of my own great sin. O Christie! never think it's time to die till you are called; for the Lord leaves us till we have done our work, and never sends more sin and sorrow than we can bear and be the better for, if we hold fast by Him."

So beautiful and brave she looked, so full of strength and yet of meek submission was her voice, that Christie's heart was thrilled; for it was plain that Rachel had learned how to distil balm from the bitterness of life, and, groping in the mire to save lost souls, had found her own salvation there.

WORK: A STORY OF EXPERIENCE, CHAPTER 7,
THROUGH THE MIST

FORGIVEN, GRATEFUL

Jesus said to him, "Simon, I have something to tell you."

"Oh? Tell me."

"Two men were in debt to a banker. One owed five hundred silver pieces, the other fifty. Neither of them could pay up, and so the banker canceled both debts. Which of the two would be more grateful?"

Simon answered, "I suppose the one who was forgiven the most."

"That's right," said Jesus. Then turning to the woman, but speaking to Simon, he said, "Do you see this woman? I came to your home; you provided no water for my feet, but she rained tears on my feet and dried them with her hair. You gave me no greeting, but from the time I arrived she hasn't quit kissing my feet. You provided nothing for freshening up, but she has soothed my feet with perfume. Impressive, isn't it? She was forgiven many, many sins, and so she is very, very grateful. If the forgiveness is minimal, the gratitude is minimal."

LUKE 7:40-47

CULTIVATE INNER BEAUTY

Mrs. Wilkins glowed with pleasure at this compliment, and leaning toward Christie, looked into her face a moment in silence, as if to test the sincerity of the wish. In that moment Christie saw what steady, sagacious eyes the woman had; so clear, so honest that she looked through them into the great, warm heart below, and looking forgot the fuzzy, red hair, the paucity of teeth, the faded gown, and felt only the attraction of a nature genuine and genial as the sunshine dancing on the kitchen floor.

Beautiful souls often get put into plain bodies, but they cannot be hidden, and have a power all their own, the greater for the unconsciousness or the humility which gives it grace. Christie saw and felt this then, and when the homely woman spoke, listened to her with implicit confidence.

WORK: A STORY OF EXPERIENCE, CHAPTER 8, A CURE FOR DESPAIR

CULTIVATE INNER BEAUTY

Cultivate inner beauty, the gentle, gracious kind that God delights in. The holy women of old were beautiful before God that way, and were good, loyal wives to their husbands. Sarah, for instance, taking care of Abraham, would address him as "my dear husband." You'll be true daughters of Sarah if you do the same, unanxious and unintimidated.

I PETER 3:4-6

SHEER GIFT

"I wish I *had* heard Mr. Power that day, for I was striving after peace with all my heart, and he might have given it to me," said Christie, interested and impressed with what she heard.

"Wal, no, dear, I guess not. Peace ain't give to no one all of a suddin, it gen'lly comes through much tribulation, and the sort that comes hardest is best wuth havin'. Mr. Power would a' ploughed and harrered you, so to speak, and sowed good seed liberal; then ef you warn't barren ground things would have throve, and the Lord give you a harvest accordin' to your labor."

WORK: A STORY OF EXPERIENCE, CHAPTER 9,
MRS. WILKINS'S MINISTER

SHEER GIFT

Consider it a sheer gift, friends, when tests and challenges come at you from all sides. You know that under pressure, your faith-life is forced into the open and shows its true colors. So don't try to get out of anything prematurely. Let it do its work so you become mature and well-developed, not deficient in any way.

If you don't know what you're doing, pray to the Father. He loves to help. You'll get his help, and won't be condescended to when you ask for it. Ask boldly, believingly, without a second thought. People who "worry their prayers" are like wind-whipped waves. Don't think you're going to get anything from the Master that way, adrift at sea, keeping all your options open.

JAMES 1:2-8

SIMPLY AND HONESTLY YOURSELF

Presently he got up with an open book in his hand, saying, in a strong, cheerful voice: "Let us sing," and having read a hymn as if he had composed it, he sat down again.

Then everybody did sing; not harmoniously, but heartily, led by an organ, which the voices followed at their own sweet will. At first, Christie wanted to smile, for some shouted and some hummed, some sat silent, and others sung sweetly; but before the hymn ended she liked it, and thought that the natural praise of each individual soul was perhaps more grateful to the ear of God than masses by great masters, or psalms warbled tunefully by hired opera singers.

Then Mr. Power rose again, and laying his hands together, with a peculiarly soft and reverent gesture, lifted up his face and prayed. Christie had never heard a prayer like that before; so devout, so comprehensive, and so brief. A quiet talk with God, asking nothing but more love and duty toward Him and our fellow-men; thanking Him for many mercies, and confiding all things trustfully to the "dear father and mother of souls."

**WORK: A STORY OF EXPERIENCE, CHAPTER 9,
MRS. WILKINS'S MINISTER**

SIMPLY AND HONESTLY YOURSELF

"It's who you are and the way you live that count before God. Your worship must engage your spirit in the pursuit of truth. That's the kind of people the Father is out looking for: those who are simply and honestly themselves before him in their worship. God is sheer being itself—Spirit. Those who worship him must do it out of their very being, their spirits, their true selves, in adoration."

JOHN 4:23-24

GOD IS LOVE

Then, when no help seemed possible, she found it where she least expected it, in herself. Searching for religion, she had found love: now seeking to follow love she found religion. The desire for it had never left her, and, while serving others, she was earning this reward; for when her life seemed to lie in ashes, from their midst, this slender spire of flame, purifying while it burned, rose trembling toward heaven; showing her how great sacrifices turn to greater compensations; giving her light, warmth, and consolation, and teaching her the lesson all must learn.

God was very patient with her, sending much help, and letting her climb up to Him by all the tender ways in which aspiring souls can lead unhappy hearts.

**WORK: A STORY OF EXPERIENCE, CHAPTER 19,
LITTLE HEART'S-EASE**

GOD IS LOVE

My beloved friends, let us continue to love each other since love comes from God. Everyone who loves is born of God and experiences a relationship with God. The person who refuses to love doesn't know the first thing about God, because God is love—so you can't know him if you don't love.

I JOHN 4:7-8

THE QUIET VOICE

Christie looked and listened with hushed breath and expectant heart, believing that some special answer was to be given her. But in a moment she saw it was no supernatural sound, only the south wind whispering in David's flute that hung beside the window. Disappointment came first, then warm over her sore heart flowed the tender recollection that she used to call the old flute "David's voice," for into it he poured the joy and sorrow, unrest and pain, he told no living soul. How often it had been her lullaby, before she learned to read its language; how gaily it had piped for others; how plaintively it had sung for him, alone and in the night; and now how full of pathetic music was that hymn of consolation fitfully whispered by the wind's soft breath.

Ah, yes! this was a better answer than any supernatural voice could have given her; a more helpful sign than any phantom face or hand; a surer confirmation of her hope than subtle argument or sacred promise: for it brought back the memory of the living, loving man so vividly, so tenderly, that Christie felt as if the barrier was down, and welcomed a new sense of David's nearness with the softest tears that had flowed since she closed the serene eyes whose last look had been for her.

WORK: A STORY OF EXPERIENCE, CHAPTER 19,
LITTLE HEART'S-EASE

THE QUIET VOICE

Then he was told, "Go, stand on the mountain at attention before GOD. GOD *will pass by."*

A hurricane wind ripped through the mountains and shattered the rocks before GOD, *but* GOD *wasn't to be found in the wind; after the wind an earthquake, but* GOD *wasn't in the earthquake; and after the earthquake fire, but* GOD *wasn't in the fire; and after the fire a gentle and quiet whisper.*

When Elijah heard the quiet voice, he muffled his face with his great cloak, went to the mouth of the cave, and stood there.

I KINGS 19:11-13

JOINED TO THE VINE

In the early dawn, when that sad wife crept fearfully to see what change had come to the patient face on the pillow, she found it smiling at her, saw a wasted hand outstretched to her, and heard a feeble voice cry bravely, "Hope!"

What passed in that little room is not to be recorded except in the hearts of those who suffered and endured much for love's sake. Enough for us to know that soon the wan shadow of a man came forth, leaning on the arm that never failed him, to be welcomed and cherished by the children, who never forgot the experiences of that time.

"Hope" was the watchword now; and, while the last logs blazed on the hearth, the last bread and apples covered the table, the new commander, with recovered courage, said to her husband:

"Leave all to God—and me. He has done his part, now I will do mine."

TRANSCENDENTAL WILD OATS

JOINED TO THE VINE

"Live in me. Make your home in me just as I do in you. In the same way that a branch can't bear grapes by itself but only by being joined to the vine, you can't bear fruit unless you are joined with me.

"I am the Vine, you are the branches. When you're joined with me and I with you, the relation intimate and organic, the harvest is sure to be abundant. Separated, you can't produce a thing. Anyone who separates from me is deadwood, gathered up and thrown on the bonfire. But if you make yourselves at home with me and my words are at home in you, you can be sure that whatever you ask will be listened to and acted upon. This is how my Father shows who he is— when you produce grapes, when you mature as my disciples."

JOHN 15:4-8

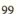

LOOK AT THE WILDFLOWERS

Silent and sad,
When all are glad.
And the earth is dressed in flowers;
When the gay birds sing
Till the forests ring,
As they rest in woodland bowers.

Oh, why these tears.
And these idle fears
For what may come tomorrow?
The birds find food
From God so good,
And the flowers know no sorrow.

If He clothes these
And the leafy trees,
Will He not cherish thee?
Why doubt His care;
It is everywhere,
Though the way we may not see.

Then why be sad
When all are glad.
And the world is full of flowers?
With the gay birds sing,
Make life all Spring,
And smile through the darkest hours.

LOUISA MAY ALCOTT, CHAPTER 2, CHILDHOOD

LOOK AT THE WILDFLOWERS

"Has anyone by fussing in front of the mirror ever gotten taller by so much as an inch? All this time and money wasted on fashion—do you think it makes that much difference? Instead of looking at the fashions, walk out into the fields and look at the wildflowers. They never primp or shop, but have you ever seen color and design quite like it? The ten best-dressed men and women in the country look shabby alongside them.

"If God gives such attention to the appearance of wildflowers—most of which are never even seen—don't you think he'll attend to you, take pride in you, do his best for you? What I'm trying to do here is to get you to relax, to not be so preoccupied with getting, so you can respond to God's giving. People who don't know God and the way he works fuss over these things, but you know both God and how he works. Steep your life in God-reality, God-initiative, God-provisions. Don't worry about missing out. You'll find all your everyday human concerns will be met.

"Give your entire attention to what God is doing right now, and don't get worked up about what may or may not happen tomorrow. God will help you deal with whatever hard things come up when the time comes."

MATTHEW 6:27-34

YOUR SINS WILL MELT LIKE ICE

TO MOTHER. [1843]

I hope that soon, dear mother,
 You and I may be
In the quiet room my fancy
 Has so often made for thee,—

The pleasant, sunny chamber,
 The cushioned easy-chair,
The book laid for your reading,
 The vase of flowers fair;

The desk beside the window
 Where the sun shines warm and bright:
And there in ease and quiet
 The promised book you write;

While I sit close beside you,
 Content at last to see
That you can rest, dear mother,
 And I can cherish thee.

November [1866].—Mother slowly mending.... I never expect to see the strong, energetic Marmee of old times, but, thank the Lord! she is still here.... Life has been so hard for her, and she so brave, so glad to spend herself for others. Now we must live for her.

LOUISA MAY ALCOTT, CHAPTER 2, CHILDHOOD,
AND CHAPTER 8, EUROPE AND "LITTLE WOMEN"

YOUR SINS WILL MELT LIKE ICE

Child, support your father in his old age; don't do something that will make him sad. If he shows signs of senility, give him a pass. Don't turn from him in his last days. Caring for a father won't go unnoticed. If your mother lashes out, give her some space. Your reputation will increase. In the day of trial you'll be remembered and your sins will melt like ice in the sun.

SIRACH 3:12-15

INVESTIGATE MY LIFE

A little kingdom I possess,
　　Where thoughts and feelings dwell,
And very hard I find the task
　　Of governing it well;
For passion tempts and troubles me,
　　A wayward will misleads,
And selfishness its shadow casts
　　On all my words and deeds.

How can I learn to rule myself,
　　To be the child I should,
Honest and brave, nor ever tire
　　Of trying to be good?
How can I keep a sunny soul
　　To shine along life's way?
How can I tune my little heart
　　To sweetly sing all day?...

Be thou my guide until I find,
　　Led by a tender hand,
Thy happy kingdom in *myself*,
　　And dare to take command.

LOUISA MAY ALCOTT, CHAPTER 3, FRUITLANDS

INVESTIGATE MY LIFE

God, *investigate my life;*
 get all the facts firsthand.
I'm an open book to you;
 even from a distance, you know what I'm thinking.
You know when I leave and when I get back;
 I'm never out of your sight.
You know everything I'm going to say
 before I start the first sentence.
I look behind me and you're there,
 then up ahead and you're there....

Investigate my life, O God,
 find out everything about me;
Cross-examine and test me,
 get a clear picture of what I'm about;
See for yourself whether I've done anything wrong—
 then guide me on the road to eternal life.

PSALM 139:1-6, 23-24

HE WILL NOT ABANDON YOU

CONCORD, *Thursday.*—I had an early run in the woods before the dew was off the grass. The moss was like velvet, and as I ran under the arches of yellow and red leaves I sang for joy, my heart was so bright and the world so beautiful. I stopped at the end of the walk and saw the sunshine out over the wide "Virginia meadows."

It seemed like going through a dark life or grave into heaven beyond. A very strange and solemn feeling came over me as I stood there, with no sound but the rustle of the pines, no one near me, and the sun so glorious, as for me alone. It seemed as if I *felt* God as I never did before, and I prayed in my heart that I might keep that happy sense of nearness all my life.

LOUISA MAY ALCOTT, CHAPTER 3, FRUITLANDS

HE WILL NOT ABANDON YOU

But even there, if you seek GOD, your God, you'll be able to find him if you're serious, looking for him with your whole heart and soul. When troubles come and all these awful things happen to you, in future days you will come back to GOD, your God, and listen obediently to what he says. GOD, your God, is above all a compassionate God. In the end he will not abandon you, he won't bring you to ruin, he won't forget the covenant with your ancestors which he swore to them.

DEUTERONOMY 4:29-31

A MEAL FROM WHAT'S LEFT

One snowy Saturday night, when our wood was very low, a poor child came to beg a little, as the baby was sick and the father on a spree with all his wages. My mother hesitated at first, as we also had a baby. Very cold weather was upon us, and a Sunday to be got through before more wood could be had. My father said, "Give half our stock, and trust in Providence; the weather will moderate, or wood will come." Mother laughed, and answered in her cheery way, "Well, their need is greater than ours, and if our half gives out we can go to bed and tell stories." So a generous half went to the poor neighbor, and a little later in the eve, while the storm still raged and we were about to cover our fire to keep it a knock came, and a farmer who usually supplied us appeared, saying anxiously, "I started for Boston with a load of wood, but it drifts so I want to go home. Wouldn't you like to have me drop the wood here; it would accommodate me, and you needn't hurry about paying for it." "Yes," said Father; and as the man went off he turned to Mother with a look that much impressed us children with his gifts as a seer, "Didn't I tell you wood would come if the weather did not moderate?" Mother's motto was "Hope, and keep busy," and one of her sayings, "Cast your bread upon the waters, and after many days it will come back buttered."

LOUISA MAY ALCOTT, CHAPTER 3, FRUITLANDS

A MEAL FROM WHAT'S LEFT

So he got up and went to Zarephath. As he came to the entrance of the village he met a woman, a widow, gathering firewood. He asked her, "Please, would you bring me a little water in a jug? I need a drink." As she went to get it, he called out, "And while you're at it, would you bring me something to eat?"

She said, "I swear, as surely as your GOD lives, I don't have so much as a biscuit. I have a handful of flour in a jar and a little oil in a bottle; you found me scratching together just enough firewood to make a last meal for my son and me. After we eat it, we'll die."

Elijah said to her, "Don't worry about a thing. Go ahead and do what you've said. But first make a small biscuit for me and bring it back here. Then go ahead and make a meal from what's left for you and your son. This is the word of the GOD of Israel: 'The jar of flour will not run out and the bottle of oil will not become empty before GOD sends rain on the land and ends this drought.'"

And she went right off and did it, did just as Elijah asked. And it turned out as he said—daily food for her and her family. The jar of meal didn't run out and the bottle of oil didn't become empty: GOD's promise fulfilled to the letter, exactly as Elijah had delivered it!

I KINGS 17:10-16

I'LL BE THERE WITH YOU

The past year has brought us the first death and betrothal—two events that changed my life. I can see that these experiences have taken a deep hold, and changed or developed me. Lizzie helps me spiritually, and a little success makes me more self-reliant. Now that Mother is too tired to be wearied with my moods, I have to manage them alone, and am learning that work of head and hand is my salvation when disappointment or weariness burden and darken my soul.

In my sorrow I think I instinctively came nearer to God, and found comfort in the knowledge that he was sure to help when nothing else could.

A great grief has taught me more than any minister, and when feeling most alone I find refuge in the Almighty Friend. If this is experiencing religion I have done it; but I think it is only the lesson one must learn as it comes, and I am glad to know it.

LOUISA MAY ALCOTT, CHAPTER 5, AUTHORSHIP

I'LL BE THERE WITH YOU

"Don't be afraid, I've redeemed you.
I've called your name. You're mine.
When you're in over your head, I'll be there with you.
When you're in rough waters, you will not go down.
When you're between a rock and a hard place,
it won't be a dead end—
Because I am GOD, your personal God."

ISAIAH 43:1-3

THERE IS NOTHING TO FEAR

Hard times she had as one may guess,
 That young aspiring bird,
Who still from every fall arose
 Saddened but undeterred.

She knew she was no nightingale,
 Yet spite of much abuse,
She longed to help and cheer the world,
 Although a plain gray goose.

She could not sing, she could not fly,
 Nor even walk with grace,
And all the farm-yard had declared
 A puddle was her place.

But something stronger than herself
 Would cry, "Go on, go on!
Remember, though an humble fowl,
 You're cousin to a swan."

FROM "THE LAY OF THE GOLDEN GOOSE,"
LOUISA MAY ALCOTT, CHAPTER 7, "HOSPITAL SKETCHES"

THERE IS NOTHING TO FEAR

Once when he was standing on the shore of Lake Gennesaret, the crowd was pushing in on him to better hear the Word of God. He noticed two boats tied up. The fishermen had just left them and were out scrubbing their nets. He climbed into the boat that was Simon's and asked him to put out a little from the shore. Sitting there, using the boat for a pulpit, he taught the crowd.

When he finished teaching, he said to Simon, "Push out into deep water and let your nets out for a catch."

Simon said, "Master, we've been fishing hard all night and haven't caught even a minnow. But if you say so, I'll let out the nets." It was no sooner said than done—a huge haul of fish, straining the nets past capacity. They waved to their partners in the other boat to come help them. They filled both boats, nearly swamping them with the catch.

Simon Peter, when he saw it, fell to his knees before Jesus. "Master, leave. I'm a sinner and can't handle this holiness. Leave me to myself." When they pulled in that catch of fish, awe overwhelmed Simon and everyone with him. It was the same with James and John, Zebedee's sons, coworkers with Simon.

Jesus said to Simon, "There is nothing to fear. From now on you'll be fishing for men and women." They pulled their boats up on the beach, left them, nets and all, and followed him.

LUKE 5:1-11

CHOSEN BY GOD

The new-comer was a little priest; so rosy and young that they called him the "Reverend Boy." He seemed rather dismayed at first; but, finding the ladies silent and demure, he took heart, and read diligently in a dingy little prayer-book, stealing shy glances now and then from under his broad-brimmed hat at Amanda's white hands, or Matilda's yellow locks, as if these vanities of the flesh had not quite lost their charms for him. By and by he fell asleep....

He was quite at their mercy now; so the three women looked as much as they liked, wondering if the poor dear boy was satisfied with the life he had chosen, and getting tenderly pitiful over the losses he might learn to regret when it was too late. His dreams seemed to be pleasant ones, however; for once he laughed a blithe, boyish laugh, good to hear; and when he woke, he rubbed his blue eyes and stared about, smiling like a newly roused baby.

He got out all too soon, was joined by several other clerical youths, and disappeared with much touching of big beavers, and wafting of cassocks. Innocent, reverend little boy! I wonder what became of him, and hope his sleep is as quiet now as then—his awakening as happy as it seemed that summer day.

SHAWL STRAPS

CHOSEN BY GOD

But you are the ones chosen by God, chosen for the high calling of priestly work, chosen to be a holy people, God's instruments to do his work and speak out for him, to tell others of the night-and-day difference he made for you—from nothing to something, from rejected to accepted.

I PETER 2:9-10

BREAD FROM HEAVEN

"What happens then? Do you go on to some other wonderful place?" asked Lily, as Muffin paused with a smile on his face.

"Yes; I am eaten by some wise, good human being, and become a part of him or her. That is immortality and heaven; for I may nourish a poet and help him sing, or feed a good woman who makes the world better for being in it, or be crumbed into the golden porringer of a baby prince who is to rule a kingdom. Isn't that a noble way to live, and an end worth working for?" asked Muffin, in a tone that made Lily feel as if some sort of fine yeast had got into her, and was setting her brain to work with new thoughts.

"Yes, it is. I suppose all common things are made for that purpose, if we only knew it; and people should be glad to do anything to help the world along, even making good bread in a kitchen," answered Lily, in a sober way that showed that her little mind was already digesting the new food it had got.

LULU'S LIBRARY, THE CANDY COUNTRY

BREAD FROM HEAVEN

But Jesus didn't give an inch. "Only insofar as you eat and drink flesh and blood, the flesh and blood of the Son of Man, do you have life within you. The one who brings a hearty appetite to this eating and drinking has eternal life and will be fit and ready for the Final Day. My flesh is real food and my blood is real drink. By eating my flesh and drinking my blood you enter into me and I into you. In the same way that the fully alive Father sent me here and I live because of him, so the one who makes a meal of me lives because of me. This is the Bread from heaven. Your ancestors ate bread and later died. Whoever eats this Bread will live always."

JOHN 6:53-58

Susan Bailey is an writer, speaker and musician. She is the author of *River of Grace: Creative Passages Through Difficult Times*. Along with her own blogs (*Be as One* and *Louisa May Alcott is My Passion*), Bailey contributes to Catholicmom.com and the Association of Catholic Women Bloggers. She writes articles and a monthly column known as "Be as One" for the Diocese of Worcester newspaper, *The Catholic Free Press*.

Bailey, who works as a marketing/advertising assistant for a local real estate firm, is an associate member of the Commission for Women of the Diocese of Worcester, Massachusetts, where previously she served as chair and secretary, helping to organize the biennial "Gather Us In" women's conference, one of the first major Catholic women's conferences in the country. As part of her duties she wrote the monthly column for *The Catholic Free Press* known as "Concerning Women."

A professional musician and graphic artist, Bailey has released four CDs; performed on EWTN, CatholicTV, and World Youth Day 2002; and served as a cantor in her parish of St. Luke the Evangelist for fifteen years. She earned a bachelor's degree in elementary education (with concentrations in U.S. History and Music) from Bridgewater State University.

She and her husband, Rich, have two grown children and live in North Grafton, Massachusetts.

LITERARY PORTALS TO PRAYER™

Hans Christian Andersen

Jane Austen

Charles Dickens

Elizabeth Gaskell

Herman Melville

William Shakespeare

Standard and enhanced-size editions
are available for each title.

800-397-2282 • ACTAPUBLICATIONS.COM